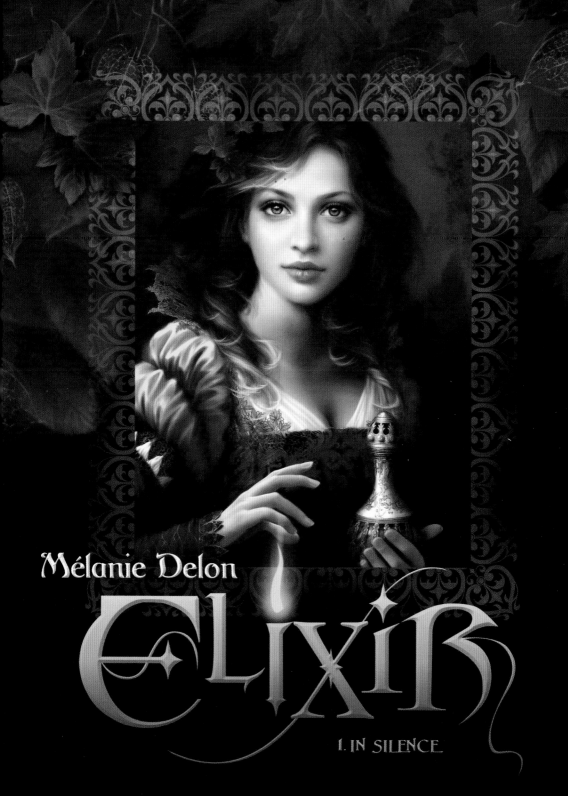

Mélanie Delon

ELIXIR

1. IN SILENCE

HEAVY METAL

To my Mum and Dad,
I will never be able to thank you enough
for your support and your love.

My brother, Thomas
for all the things you have done for me...

My dearest friends, Honorine and Thomas
for all the moments we spent together.

And to Jean-Philippe, for everything else...

ELIXIR, by Mélanie Delon
ISBN 978 1935351009

© Mélanie Delon / Represented by Norma Editorial

Published by Heavy Metal ©
100 North Village Avenue, Suite 12,
Rockville Centre, NY 11570

www.NormaEditorial.com
www.MelanieDelon.com

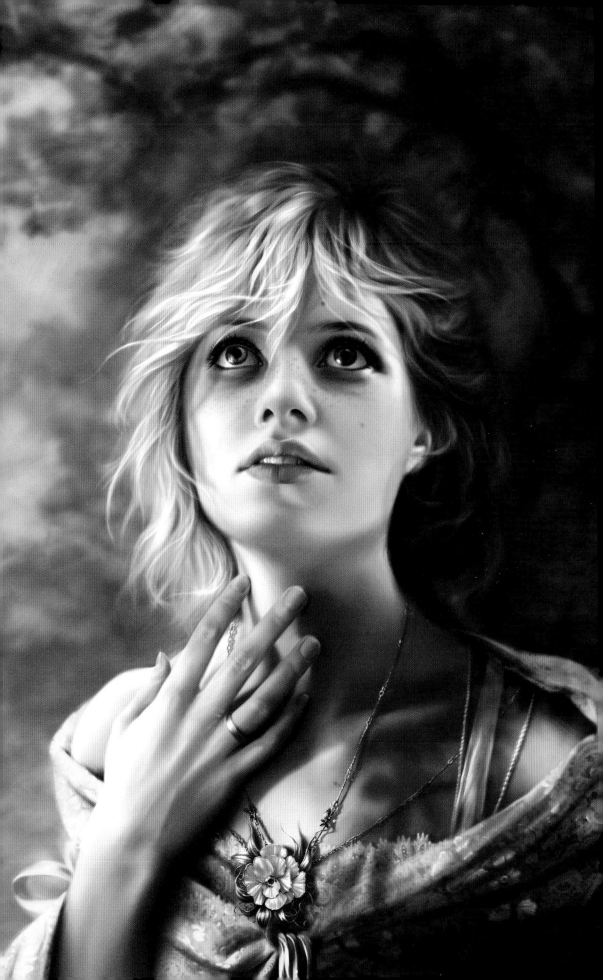

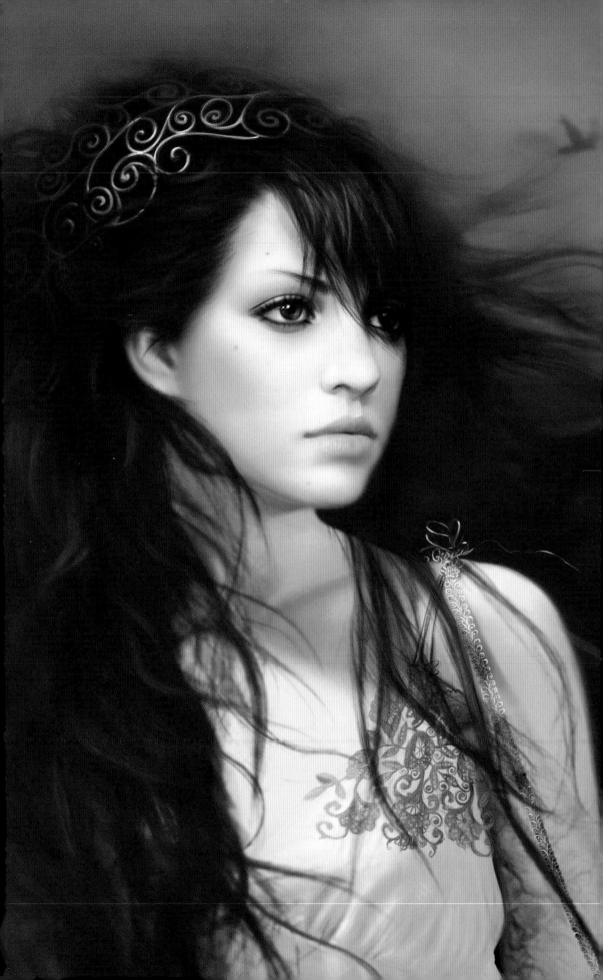

Fantasy and painting have always been a part of my life. I've drawn and dreamt about fantasy worlds since the beginning.

Giving life to those characters with my illustrations was quite natural and pleasing to my eyes.
I love painting, colors and also telling stories. Seeing my illustrations arise from under my brush strokes is a wonderful and irreplaceable moment, a kind of dream that comes to life.

Each painting is different. I need this diversity, as much in the colors as in the stories and the expressed emotions .All these illustrations represent one particular moment in the life of my characters, a moment of loneliness, of silence, most of the time intimate moments which are not supposed to be shared...

This book is an invitation to travel and dream, I hope that you will take as much pleasure to read and discover it as I had in creating it...

MÉLANIE DELON
September 2007

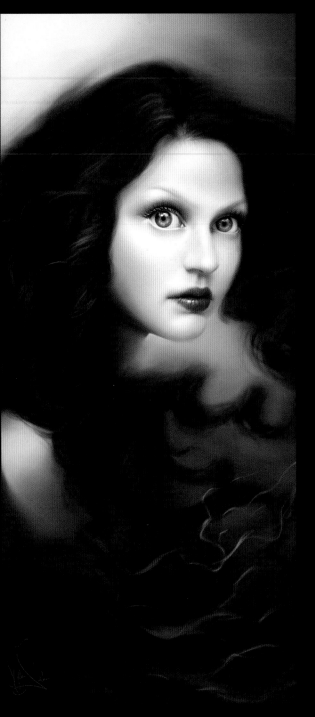

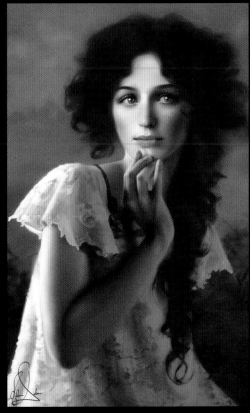

Bergamote 02/2007 ⚜

Glory loves reading fairy tale books, and when she's in her garden she lets her imagination flow. She searches for little fairies in trees or grass. She truly believes there is a magical land and searches through each forest of her country. People usually laugh at her, but she doesn't care about what they think of her.

Runaway 12/2006 ⚜

Illsyh is a child of the night. Her immaculate skin does not allow her to live in the light of the sun. She and her people live hidden in the "Caves of the Firmament" since the night of times and dream of the day they will be finally able to taste the soft heat of this mysterious star.

Déchainée 04/2006 →

This world is far from me, my heart is dry, and life is a constant pain. I can no longer live in a world that is so cruel. May the Gods be merciful and bring peace to my people.

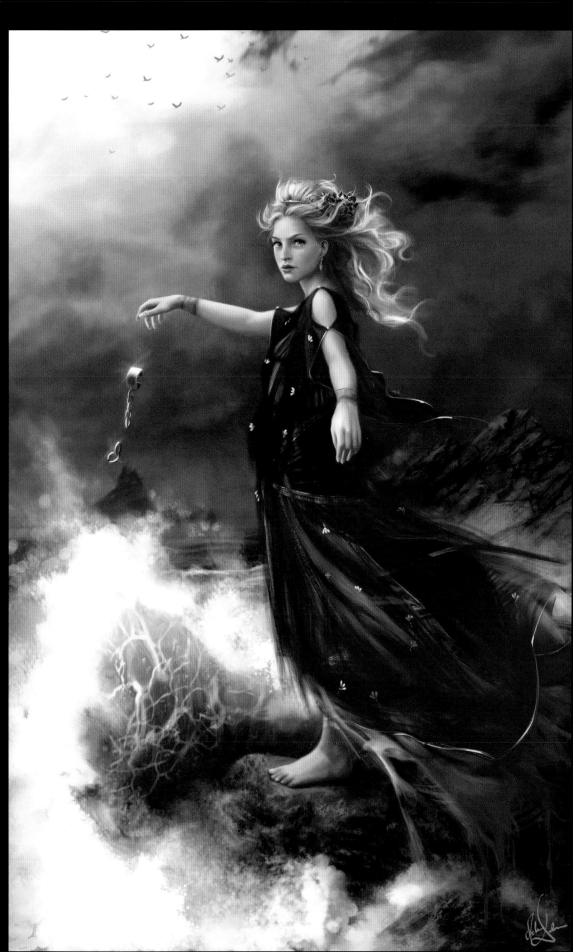

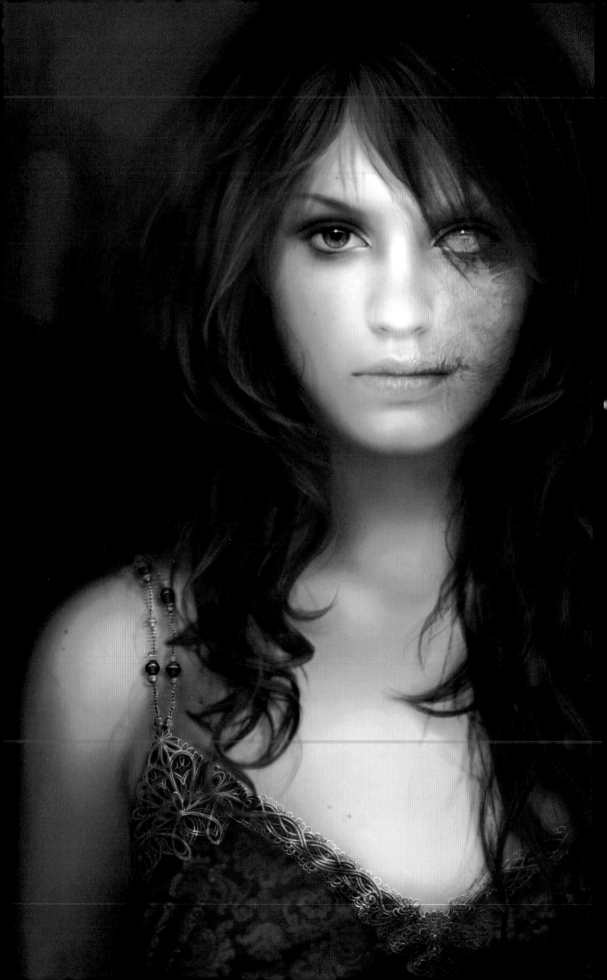

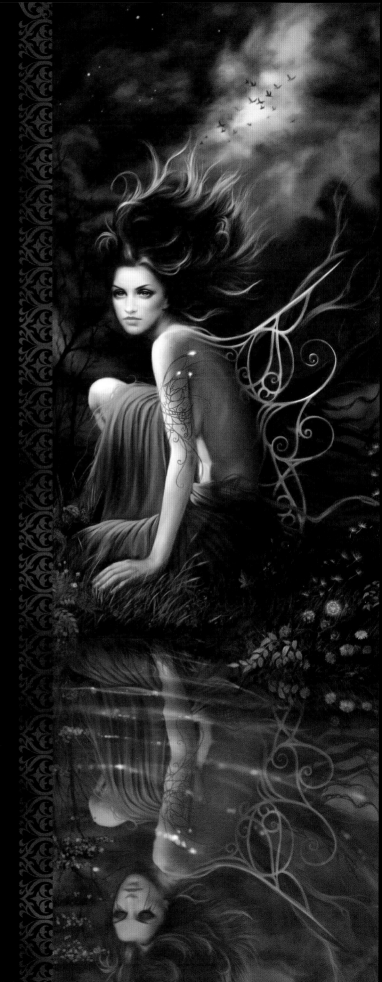

Eyllrië is a dark witch. She's the apprentice of the most powerful witch of the world. But practicing the dark arts, is not without danger. She pays for her knowledge with her beauty, her skin begins to rot, and one of her eyes starts to see not only the real world but also the other one...

WONDERING 09/2005 →

Lyhyah, one of the spirits of nature, is alone and lost... lost because she loves a mortal man, and her people don't accept such an alliance. She must choose between a human life or living eternally, but without love.

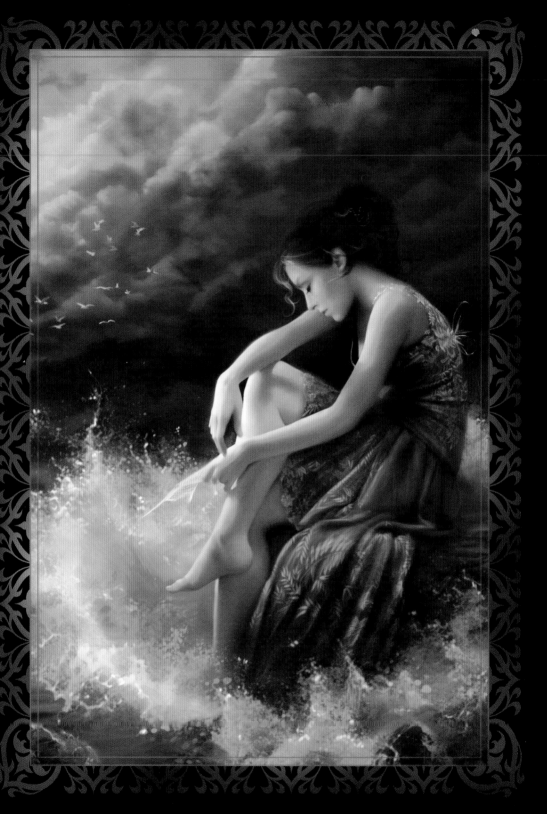

AT THE END 07/2007 ✝

"My love, it seems like I've been so far from you for so long. I languish your smile, your voice, your perfume.
My only comfort is that soon we will be together.
The battle was difficult, and absurd, many of my companions fell, and too many innocent died, but I return
to you victorious, knowing our future is protected. I'll take the first ship back to our beautiful country.
We are leaving tomorrow, so this is the last letter I can send you. Once in your arms nothing will separate us
and we will be finally happy. I love you A.H "

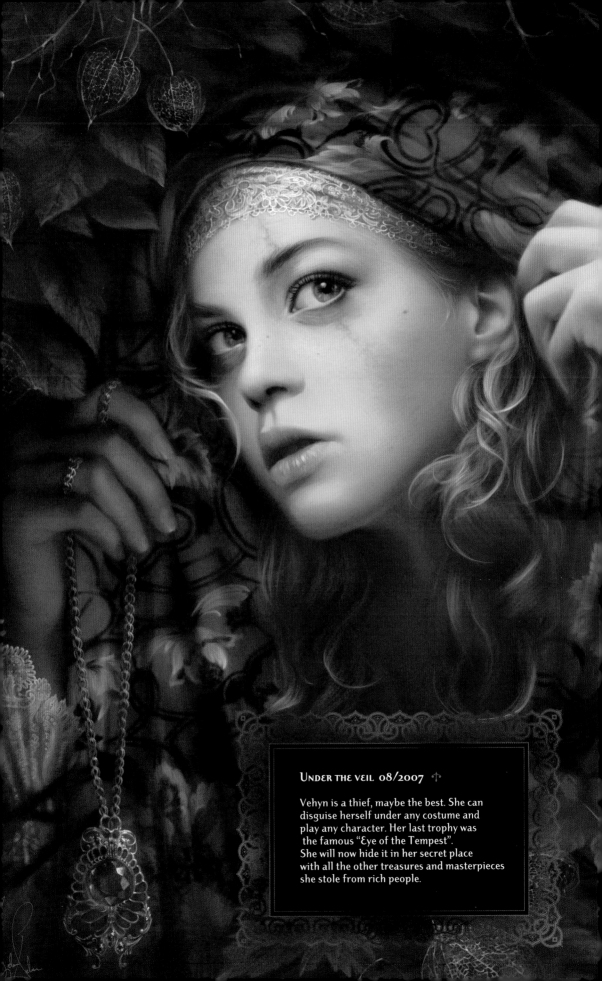

UNDER THE VEIL 08/2007 ⚜

Vehyn is a thief, maybe the best. She can
disguise herself under any costume and
play any character. Her last trophy was
the famous "Eye of the Tempest".
She will now hide it in her secret place
with all the other treasures and masterpieces
she stole from rich people.

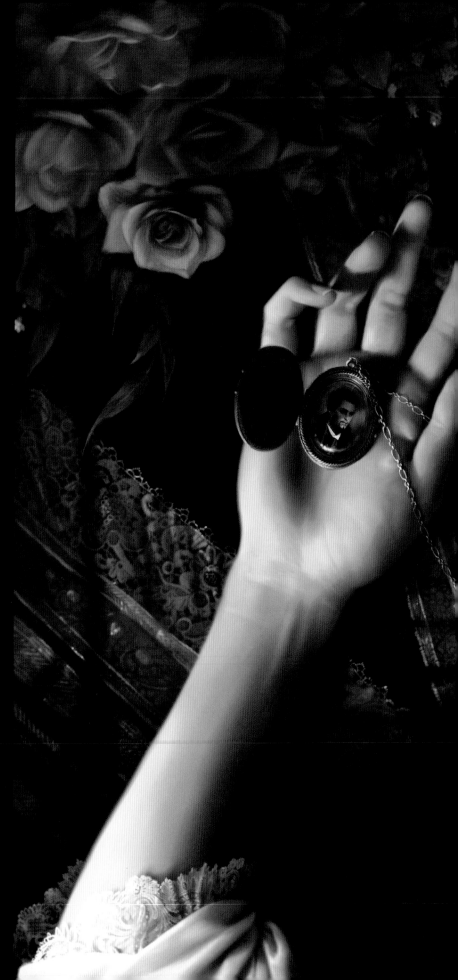

Victoria is almost dead, her dear lover is with another woman. She can't stand the pain and each day since their separation she fades away more. Her family is helpless and can only watch her dying.

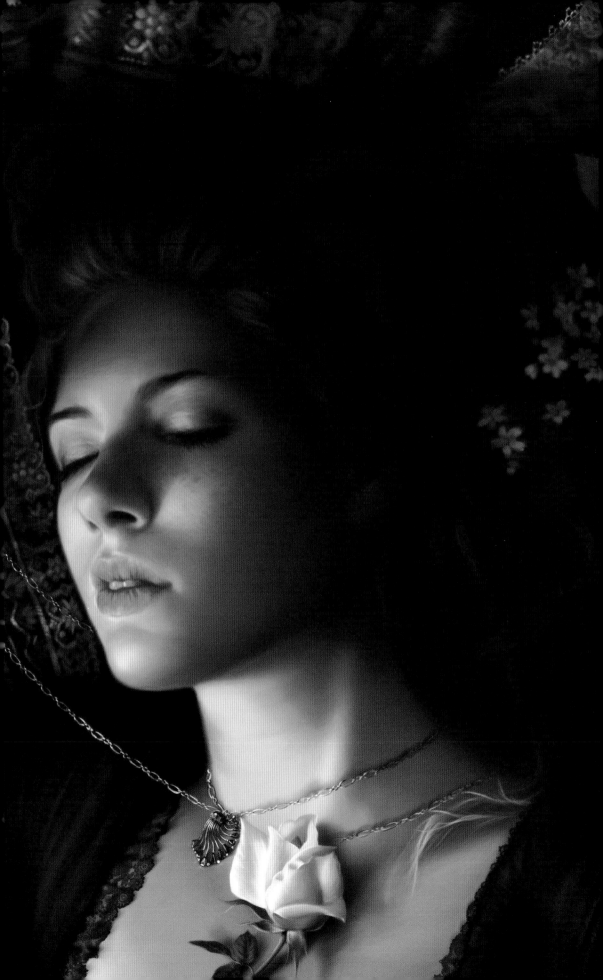

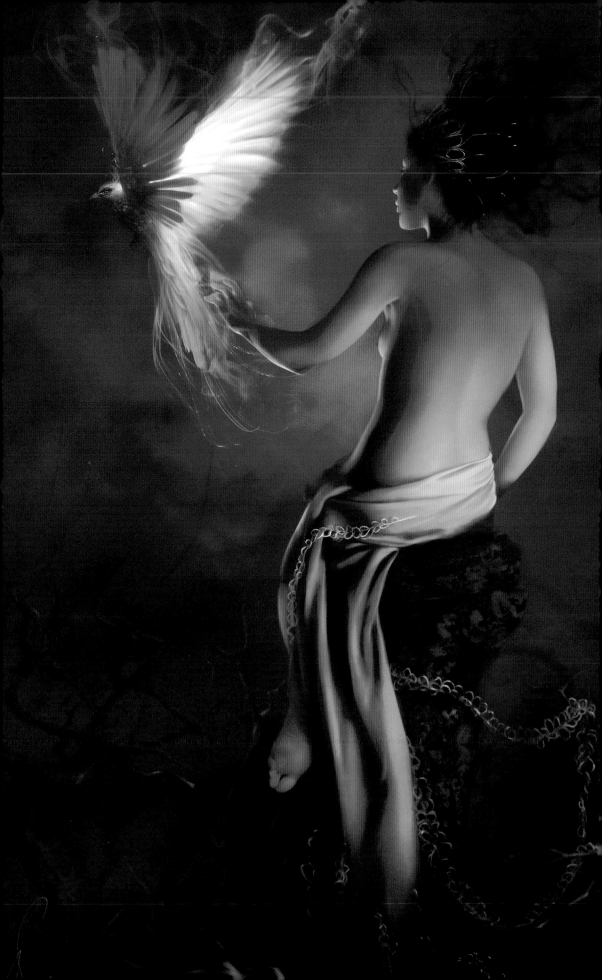

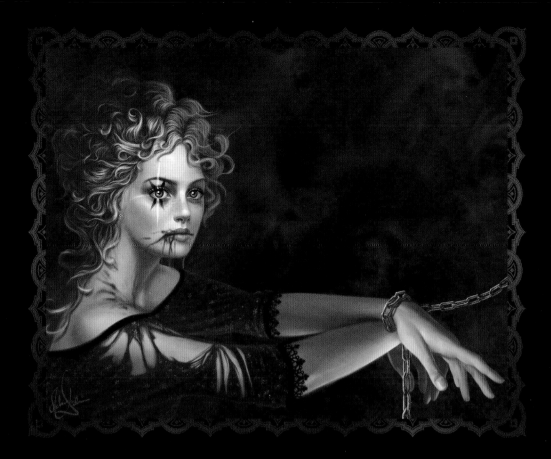

So funny 12/2005 ↑

Shislen is mental. Since her childhood,
she's had no morals, she simply
doesn't know what those words mean.
She's a clown, its the only work she can do,
and when someone doesn't like her show,
she can easily kill him...

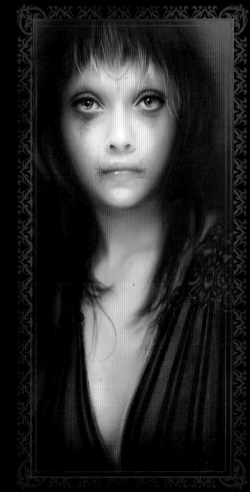

Fool 07/2007 →

In the temple of Askare, Etuim is the
"Aurore". She can predict the future and
invoke ancient spirits as well as demons.
She's feared and respected by all the people,
but her life is empty and sometimes when
sadness and loneliness are too much for her,
she releases powerful storms upon the
temple to wash her pain away.

← Red sun 04/2007

In the dark abyss of the gold mountain lives
the lady of the fire, Nahhily. She can control
heat, and has the power to destroy each life
around her. But she's doomed because of her
power. Her only companion is a phoenix,
he's the only one who can approach her
without dying...

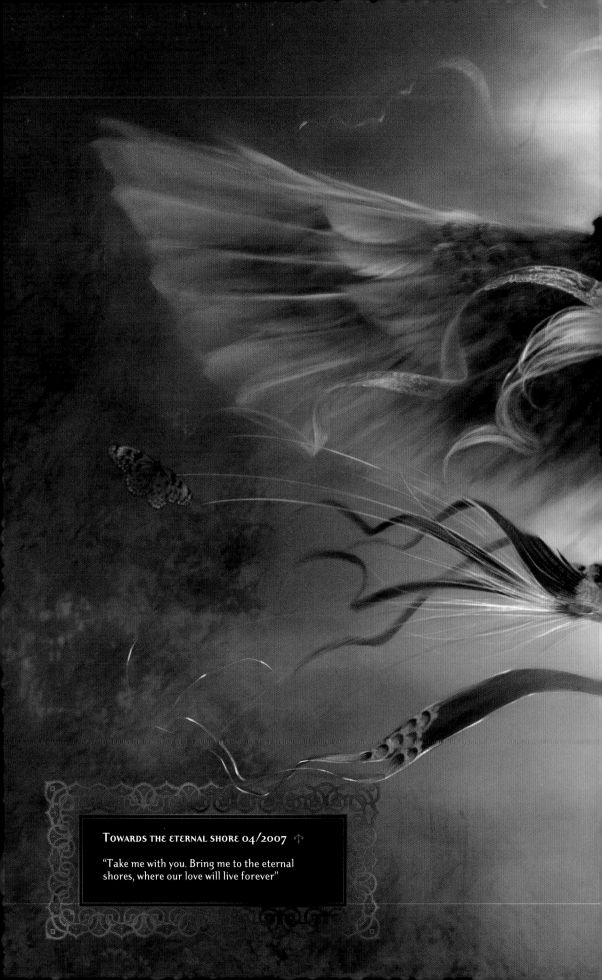

TOWARDS THE ETERNAL SHORE 04/2007 ⚓

"Take me with you. Bring me to the eternal
shores, where our love will live forever"

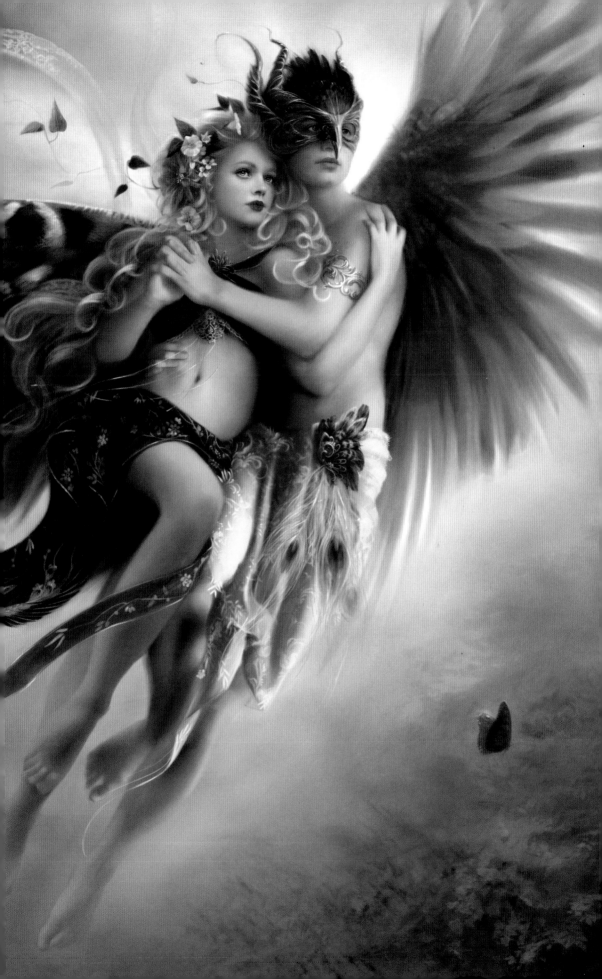

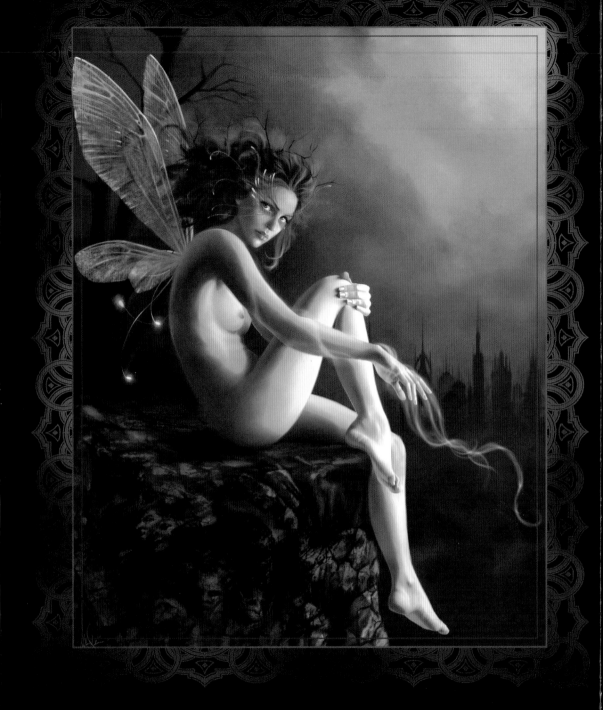

Not alone 04/2006 ⇡

In the heart of the "Shadow forest", lives Dilia, who after swimming in the Lake of Xiklehy, has been transformed into a fairy and forced to stay alone. To avenge herself, she attracts poor hunters and imprisons them forever. When the wind blows, the inhabitants of the valley hear noises that sound like screaming coming from the forest.

Hands of fate 04/2007 ⇢

"I'm Fate, you cannot see me, unless I want you to. I can be your friend or your enemy, but I can't be fooled. I'm your shadow and I whisper in your ears when you're asleep. You are my puppet and I love playing games..."

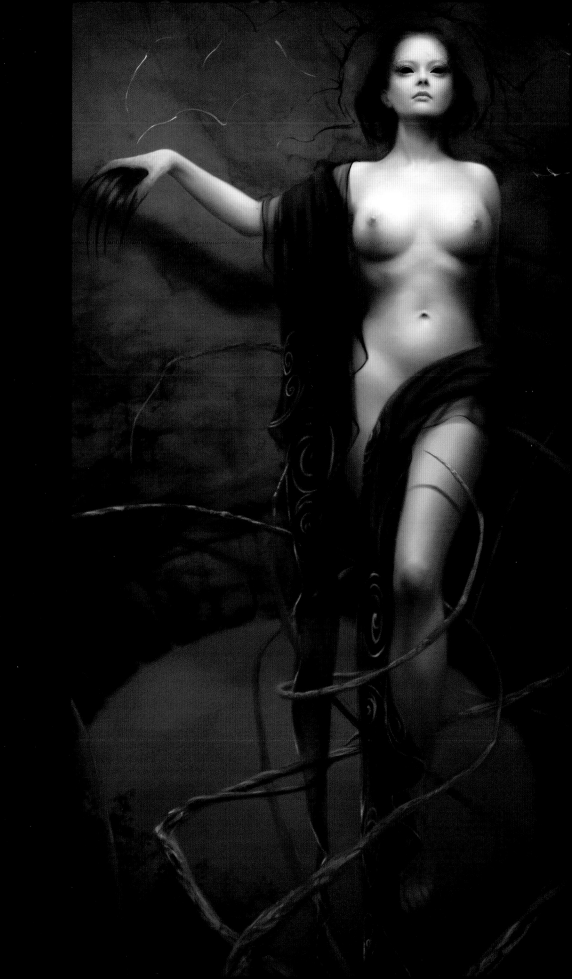

Myshae "Dusk star" lived in the mountains of the twilight, until one day she discovered a dying man. For a month, she took care of him, healing his wounds, and they fell in love. Unfortunately, he has to leave her. He was the bearer of an important message for the King. He promised to come back to her and gave her his medallion so that she could never forget him.

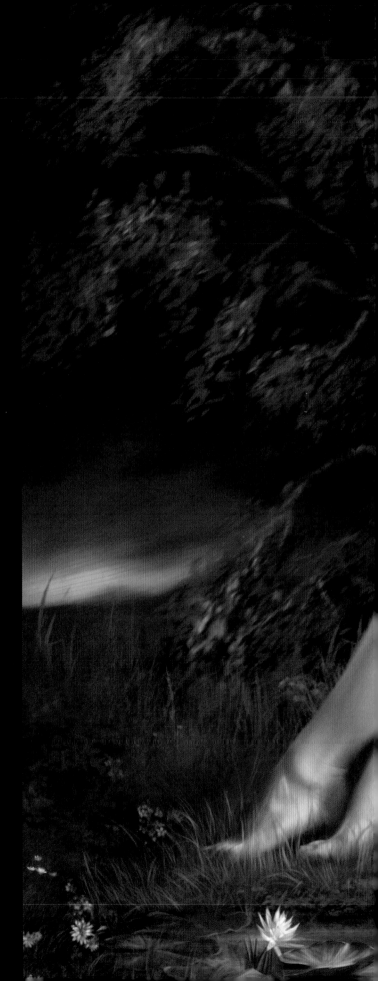

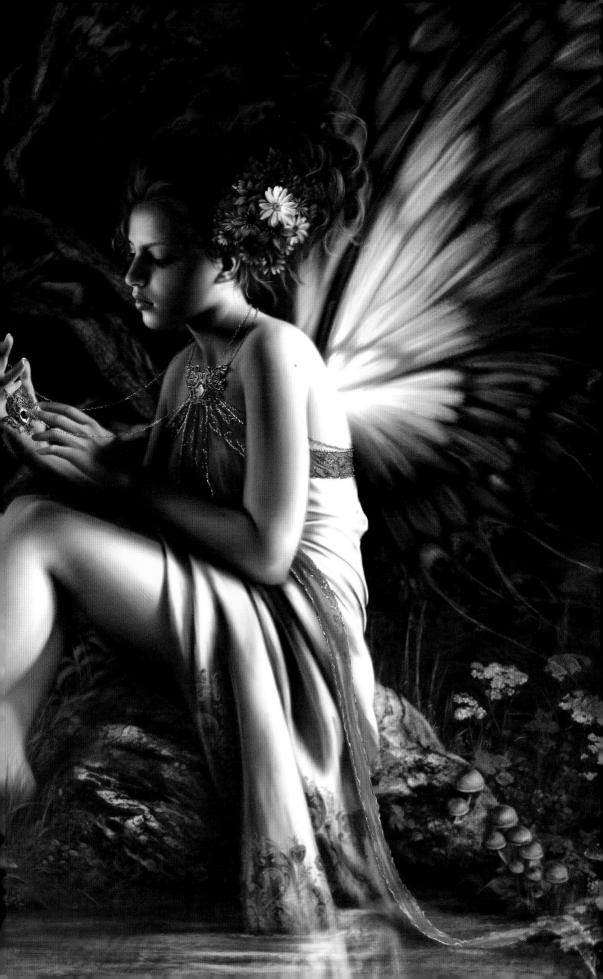

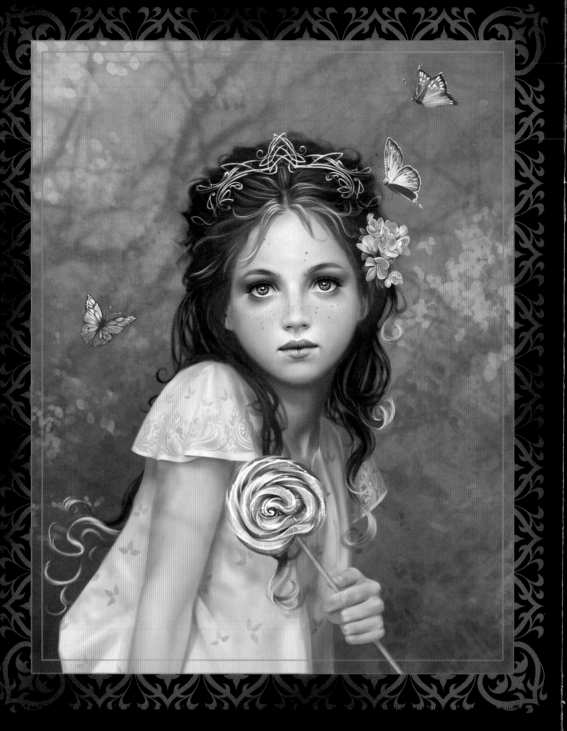

ROCK CANDY 02/2006 ⇑

Lucy is a princess, and like a lot of children she loves candy,
but don't trust her innocent looks, because she's a little demon.
She loves playing tricks too.

<div align="right">

SONG OF THE SHADOWS 08/2007 ⇒

After her accident, Jaïlis became deaf. She was a great violinist, and
now she can only hear the ghosts and the shadows' whispers...

</div>

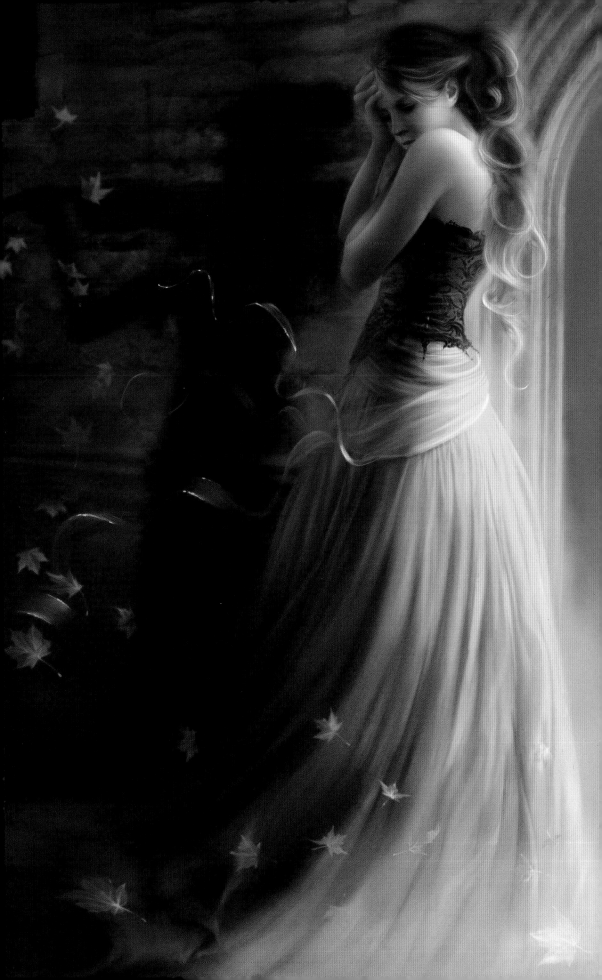

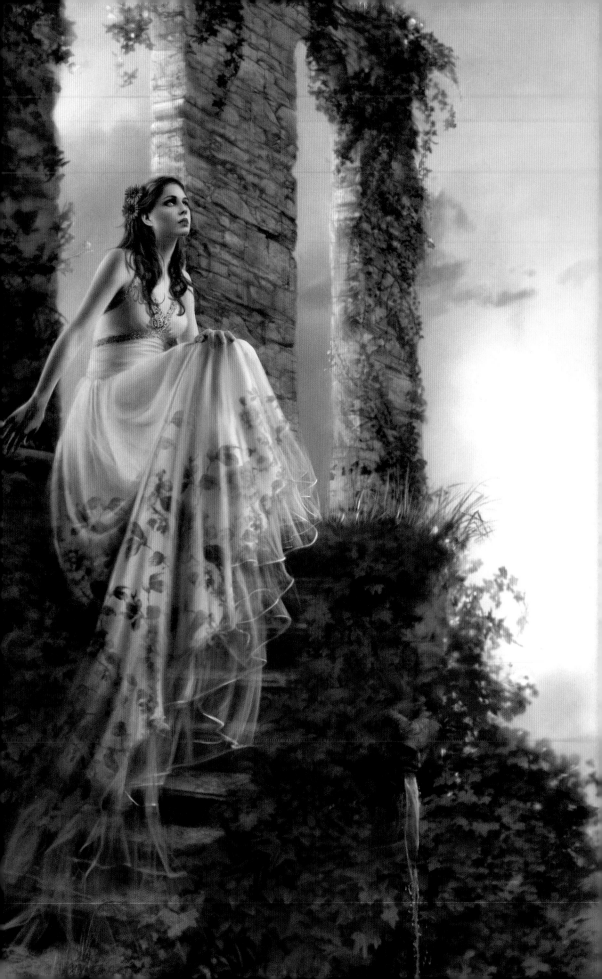

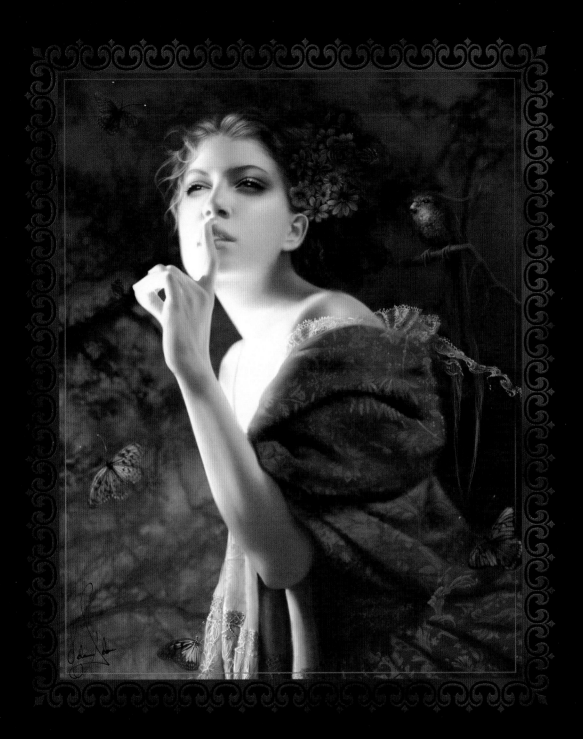

⚜ **Surprise 02/2007**

Asyllia is an enchantress. She's the queen of the forest. She takes care of and protects this land, and she spends her time playing tricks on poor peasants. They know she's not evil, so they are not afraid of her...

⚜ **What I see 03/2007**

She was only a child when her parents died during the attack on her city, Naëry was the only survivor and the king of this land offers her his home. He raises her like his own daughter. Despite all this love, she always feels alone, her parents haunt her each day. She takes long walks through the land of her childhood, and sometimes she stays out for many hours near the ruins of her ancient home trying to remember her parents' faces while the sun fades out beyond the mountains.

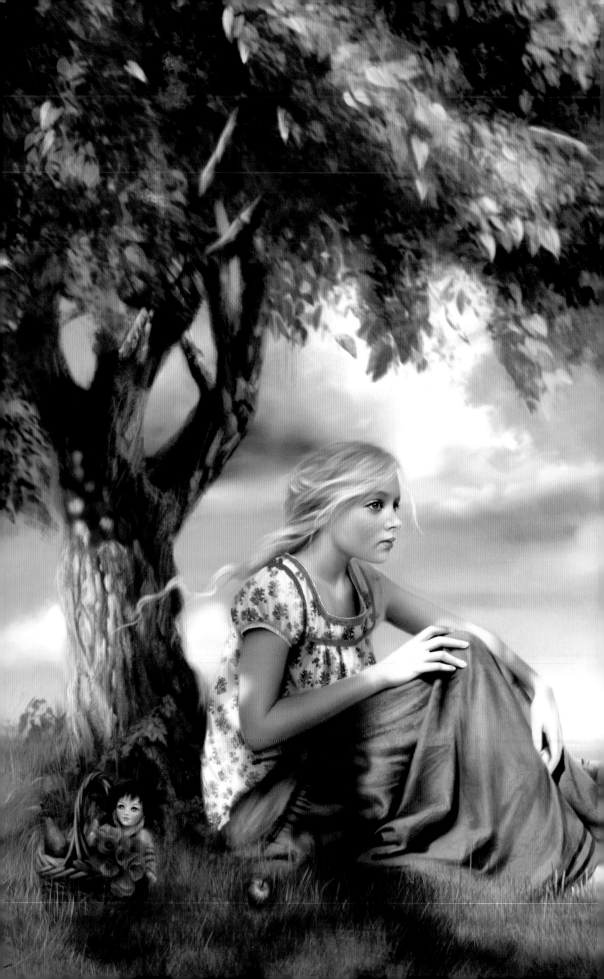

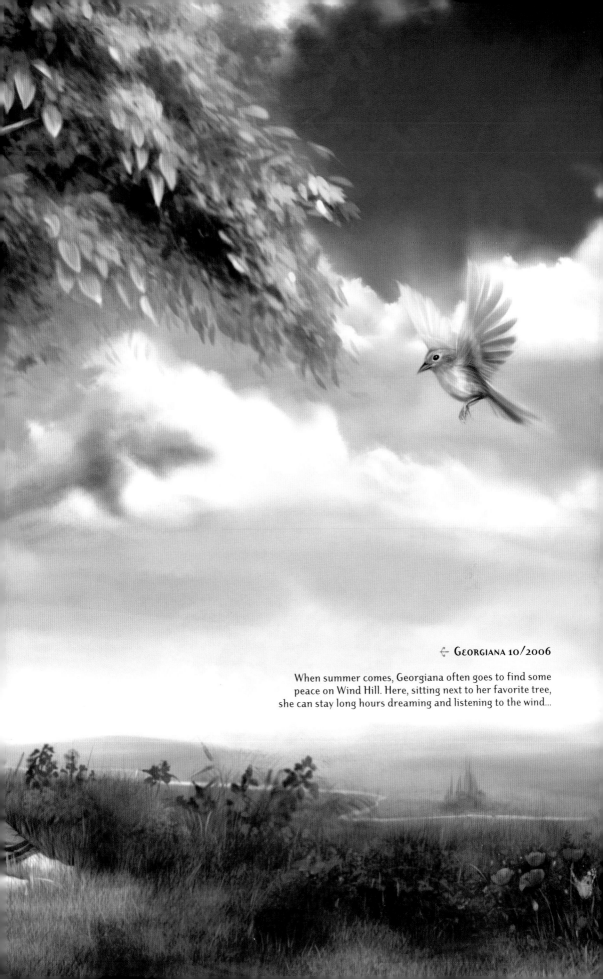

← GEORGIANA 10/2006

When summer comes, Georgiana often goes to find some
peace on Wind Hill. Here, sitting next to her favorite tree,
she can stay long hours dreaming and listening to the wind...

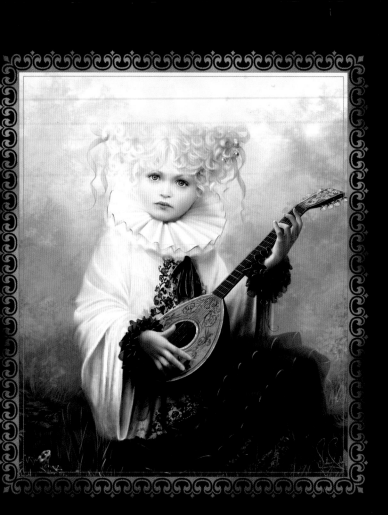

INNOCENT 11/2006

Thiislly is a kind of fairy. She appears when people are sad or lost.
She plays music for them, to bring them happiness.

GHOST OF WINTERLAND 02/2007

In the white forest of the "Crystal Winter", lives the Snow queen.
Her heart is cold as ice, and she's cruel and has no pity for humans.
She doesn't hesitate to lock them under ice for her own delight
and watch their agony with her beloved and loyal owl.

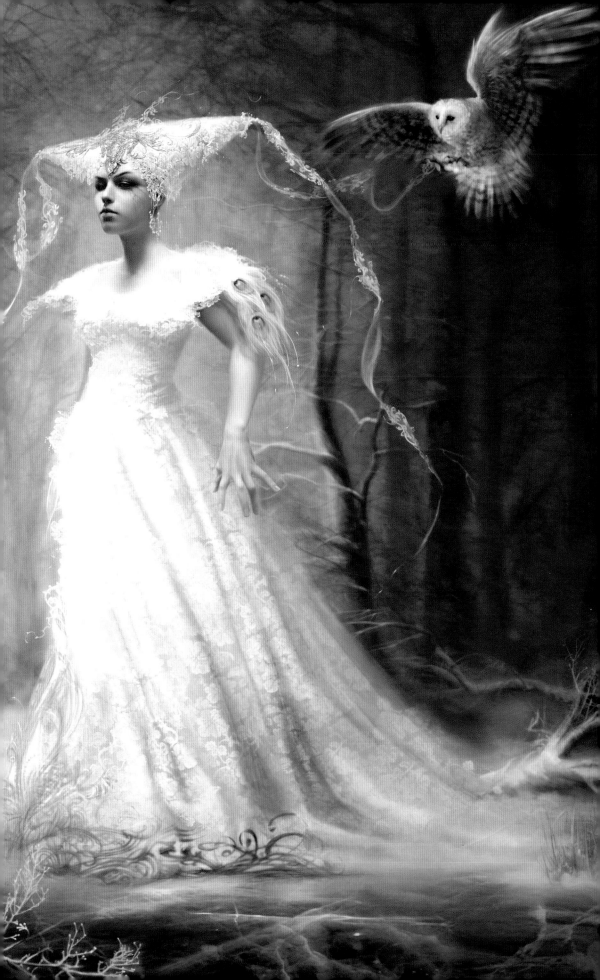

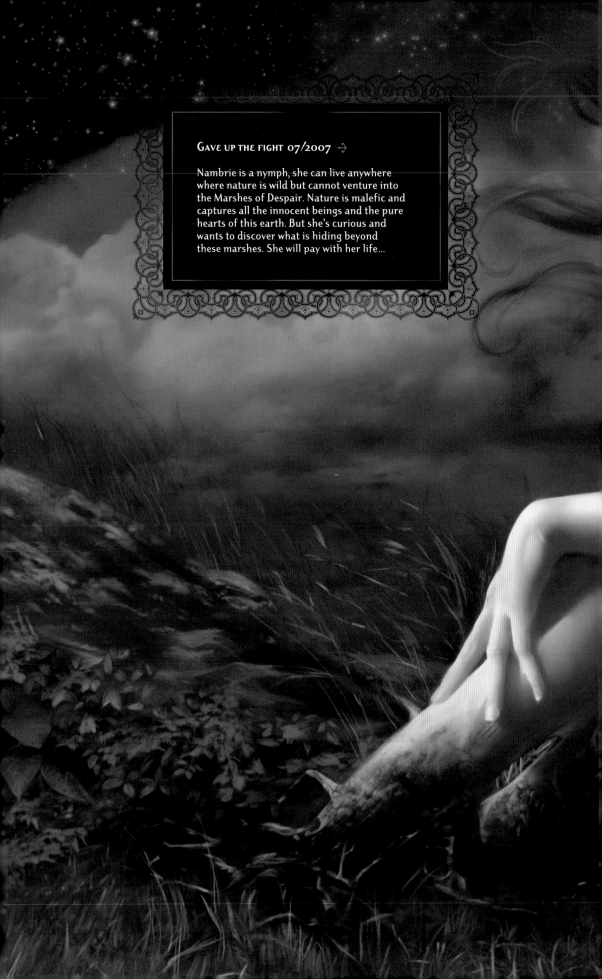

GAVE UP THE FIGHT 07/2007 →

Nambrie is a nymph, she can live anywhere
where nature is wild but cannot venture into
the Marshes of Despair. Nature is malefic and
captures all the innocent beings and the pure
hearts of this earth. But she's curious and
wants to discover what is hiding beyond
these marshes. She will pay with her life...

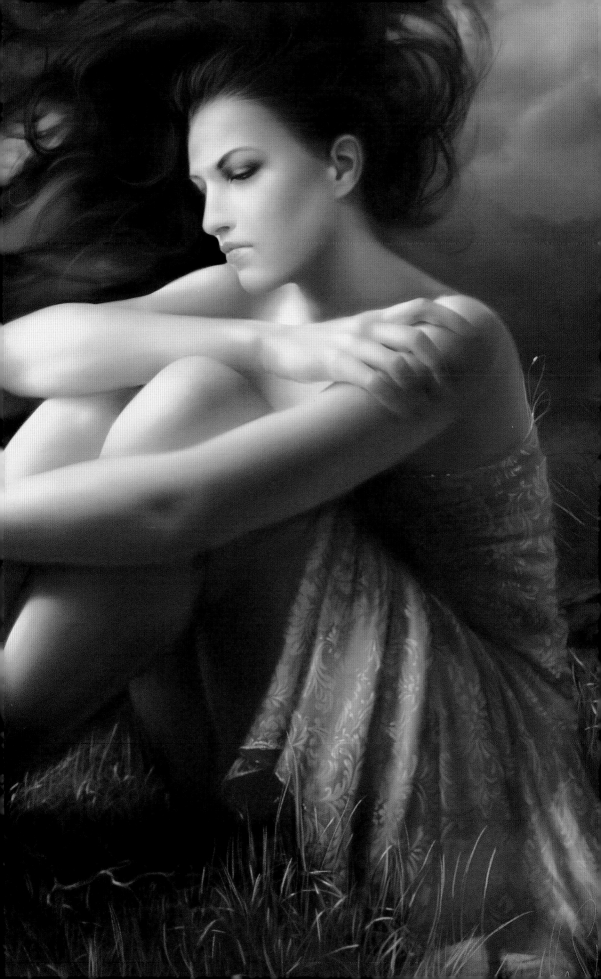

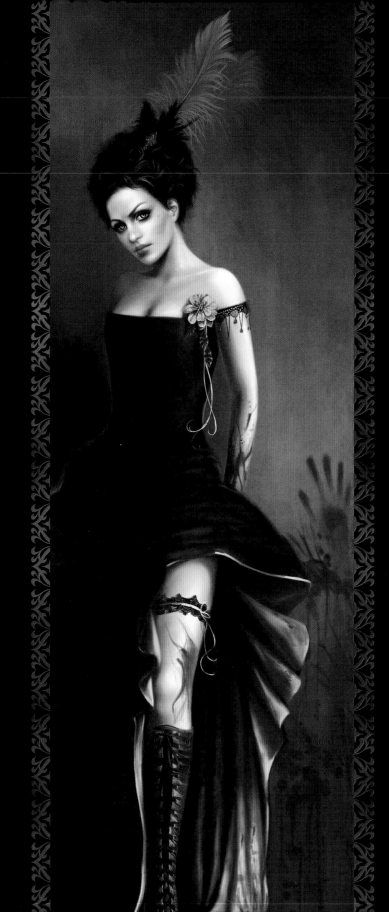

"Come to me, I need your love.
Say you're mine and I'll take your life."

Do you want to play with me?
11/2006 →

Aldéria, a demonic genius of
games, roams from village to
village in search of an easy pray.
She plays with the souls
and the lives of the neediest,
promising them glory and
fortune if they were ever to win.

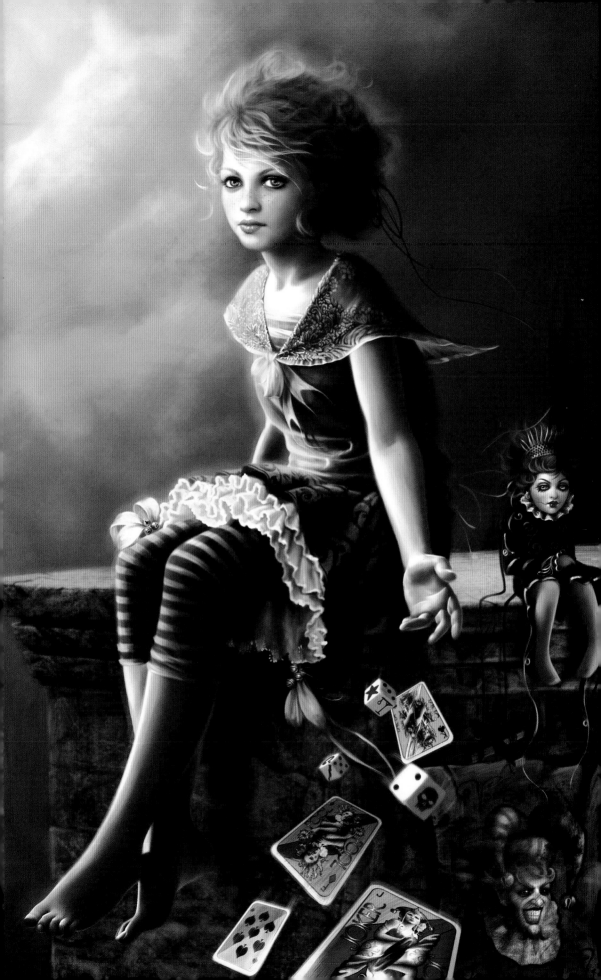

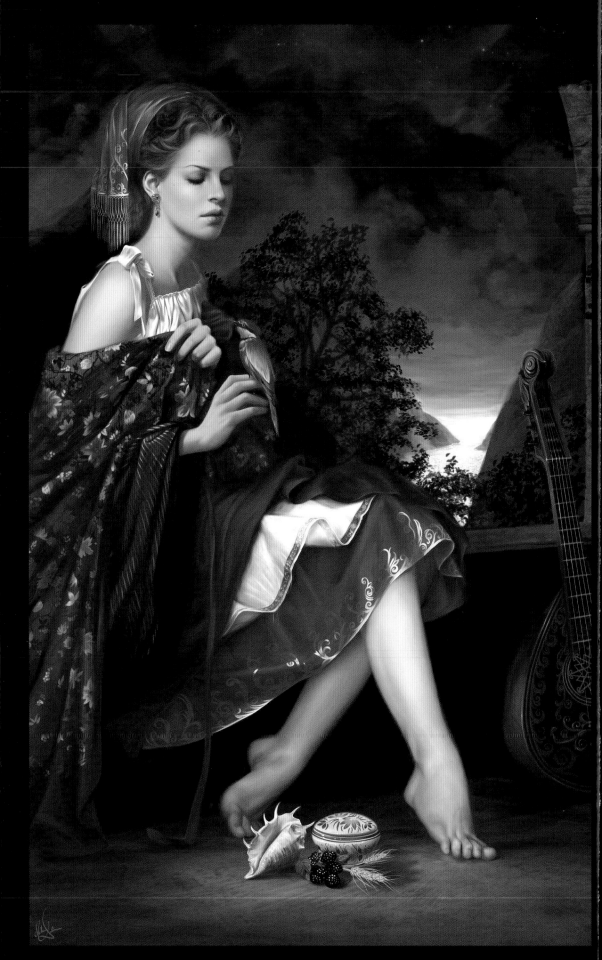

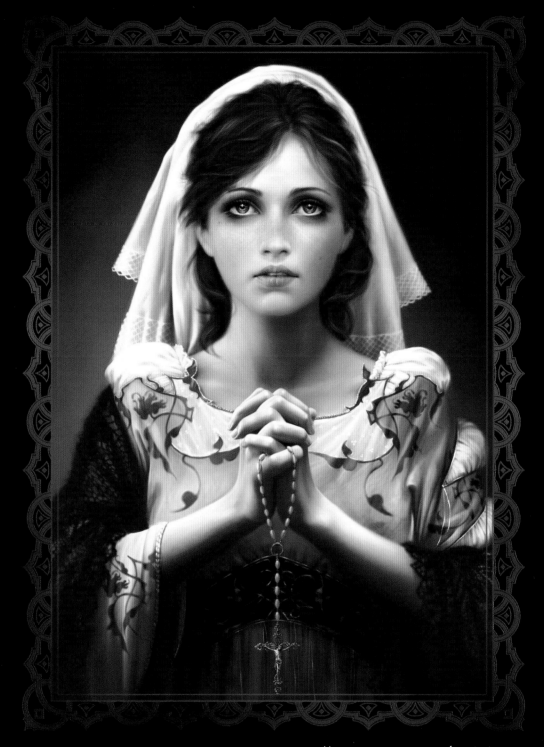

NOTHING WILL SAVE ME 07/2006 ✠

Agathe committed a crime. She carries the child of the heir to the throne. They are not
married and never will be able to, since she's not from royal blood. When the Church
discovers their secret, Agathe will not have any hope, she will be condemned to death...

← PEARL 04/2006

Her name is Myrhaelle and she lives alone on an island. She is the last descendant of the
lords of this earth. She spends her days in the ruins of the ancient city, and often when
the wind rises and blows through the walls of the old city she plays music in memory of
the past... and who knows, maybe one day someone will hear her song.

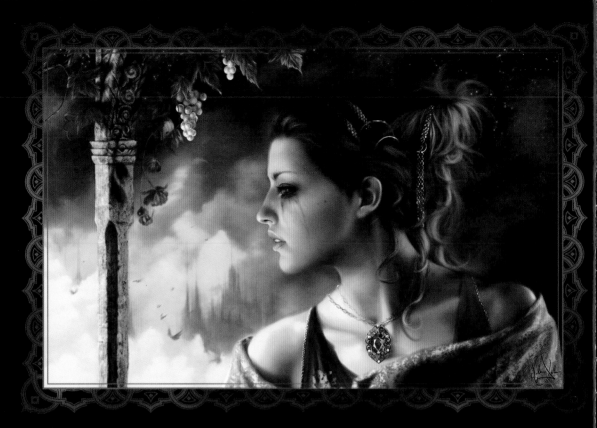

I'm not believing 10/2006 ⚓

In the high city of Celestia, war is coming. The enemy is at the gates. Despite all the messages of peace her father, the King, sent them, they still want to conquer this last land of freedom. Opale can only watch and pray for victory.

Abîme 06/2007 ⚓

"The light is fading, the water is cold, but I don't feel sadness or pain, because I'll soon be with you, in the abyss where darkness is the king."

Colombine 07/2006 →

Born to a family of noble merchants who died in a fire, Colombine was taken in and raised by a group of gypsy actors. She has been living on her own for a few years and she now travels all over the world to find her parents' murderers. She's a recluse and she earns money dancing and playing music in public places.

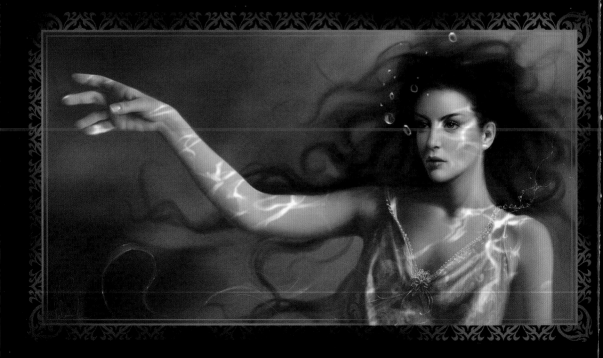

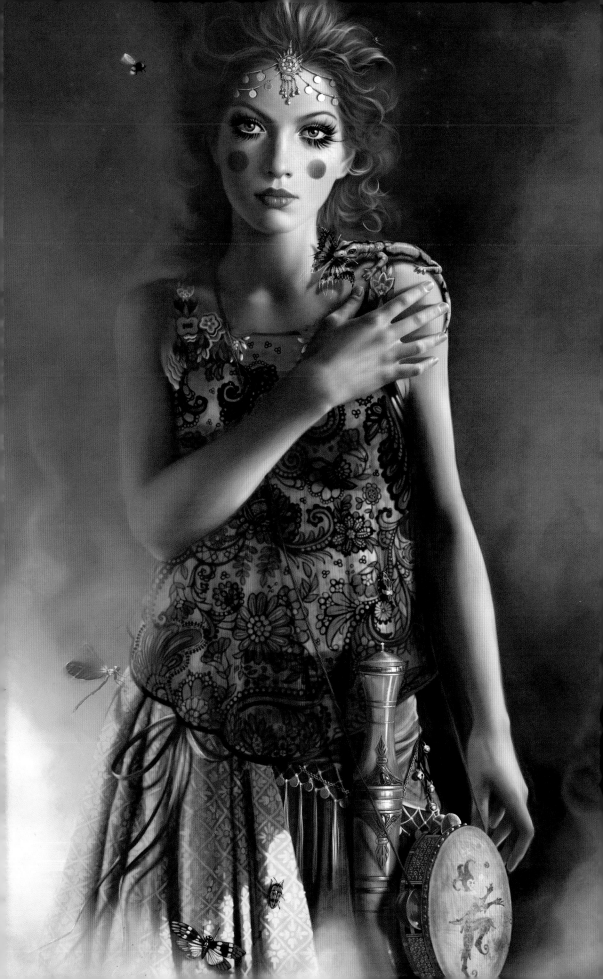

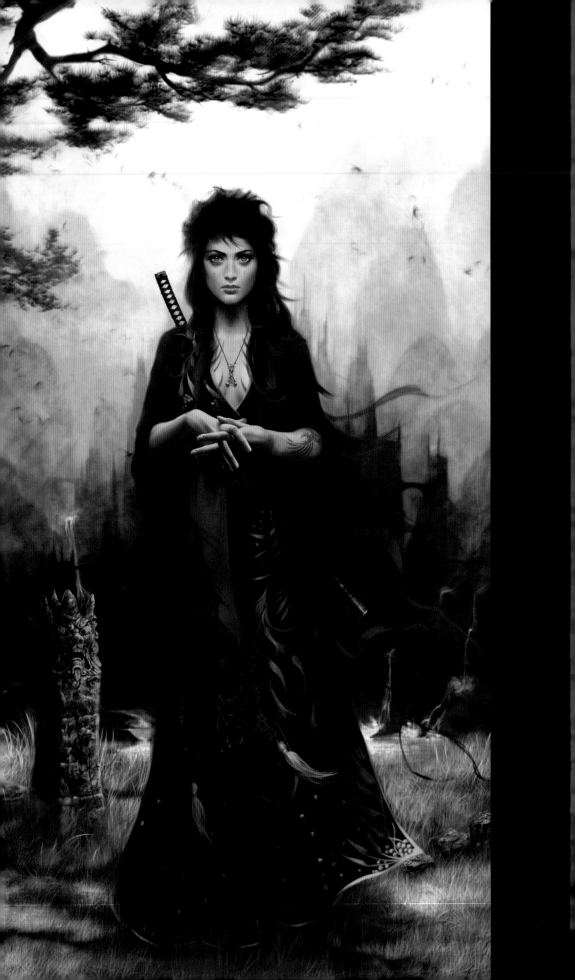

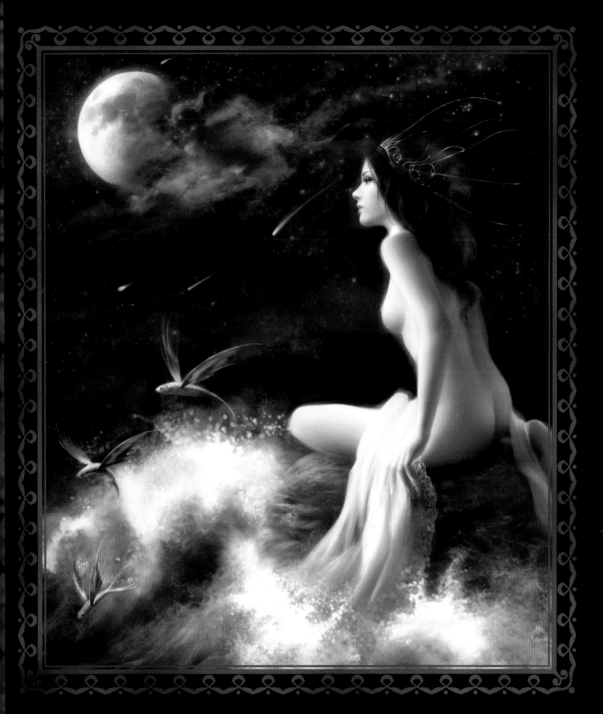

DAYDREAMING 09/2007 ↑

Coereil, is Queen of the Azure Sea, the most cold and dangerous sea. She rules the storms.
Nobody ever dared to sail on these waters. Legend says that they are cursed. But when the stars are
dancing, once every seven years, she sits down and dreams of a mortal life, and she makes a wish.
Always the same since hundreds of years ago, and hopes this time it will be fulfilled.

← **ALL MY HATE 10/2006**

Sandre, wife of the most famous swords maker of the country, saw her entire family die, her
husband and her three children, at the hand of the most terrible murderer of the city. Her husband
refused to make a sword for him, and for that, he was decapitated. When Sandre discovered this
massacre, hate immediately took over in her heart, and she swore to avenge her family's death.

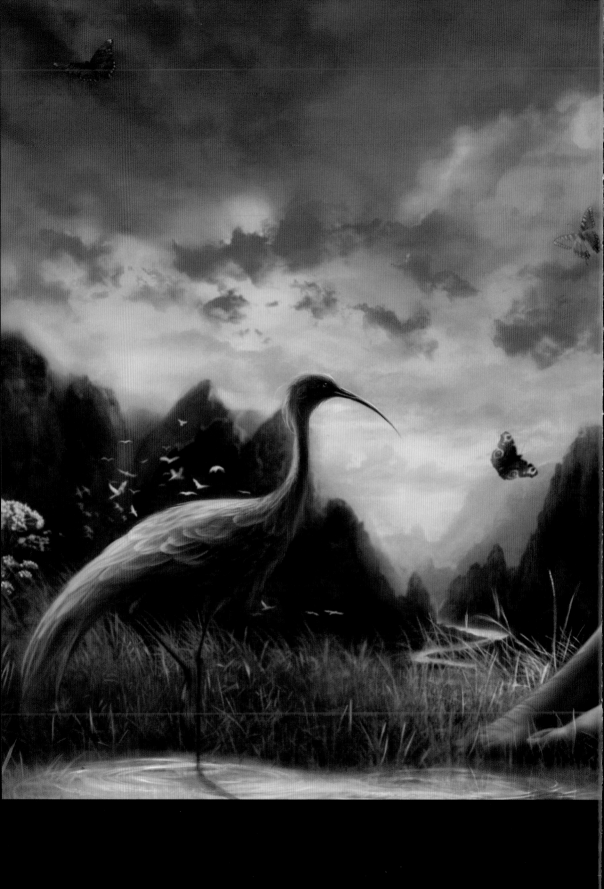

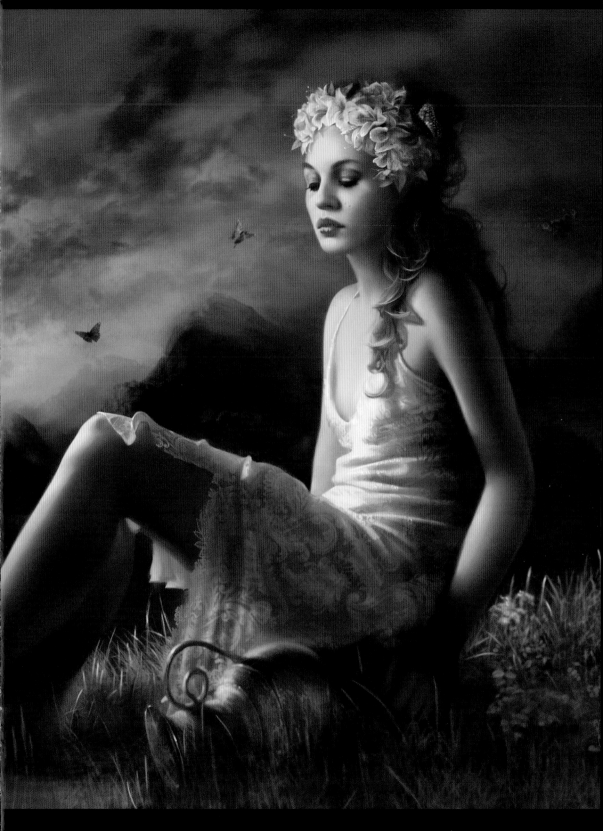

Every day before sunset Lydia goes on the top of the hill to see her sister. She was transformed into a bird [by a] diabolic sorcerer. Lydia does not want to see her like tha[t,] tonight she brings her a beverage, and hopes Death will lead her to a better life where she could finally be happy.

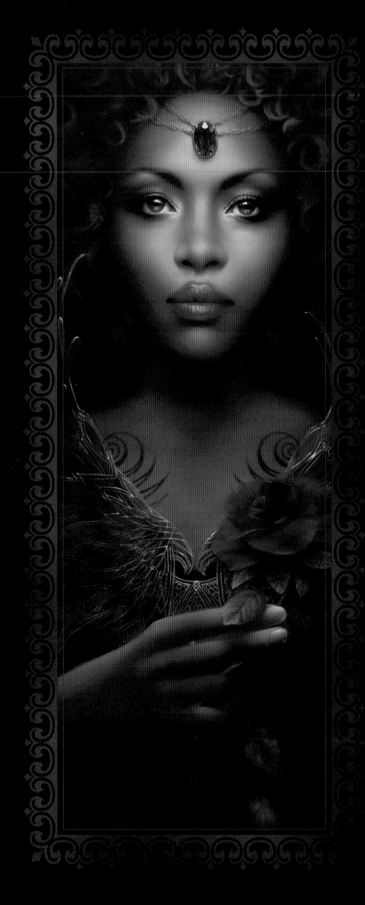

Elliscia is the sunlight. She brings happiness and joy to the hearts of men, nothing is dark in her. She's the most beloved goddess of this land. A long time ago she was mortal, but she gave her life in sacrifice to save her family, and the gods rewarded her for this, giving her eternal life.

Eve is the last keeper of the golden keys which lead to the kingdom of dreams. She came at night when everyone was asleep, and stole the dreams and locked them in her kingdom. Nobody has ever seen it, but legend says that there are four doors, the first leads to the land of "no dreams", it's a devastating land. The second one is the one of nonsense

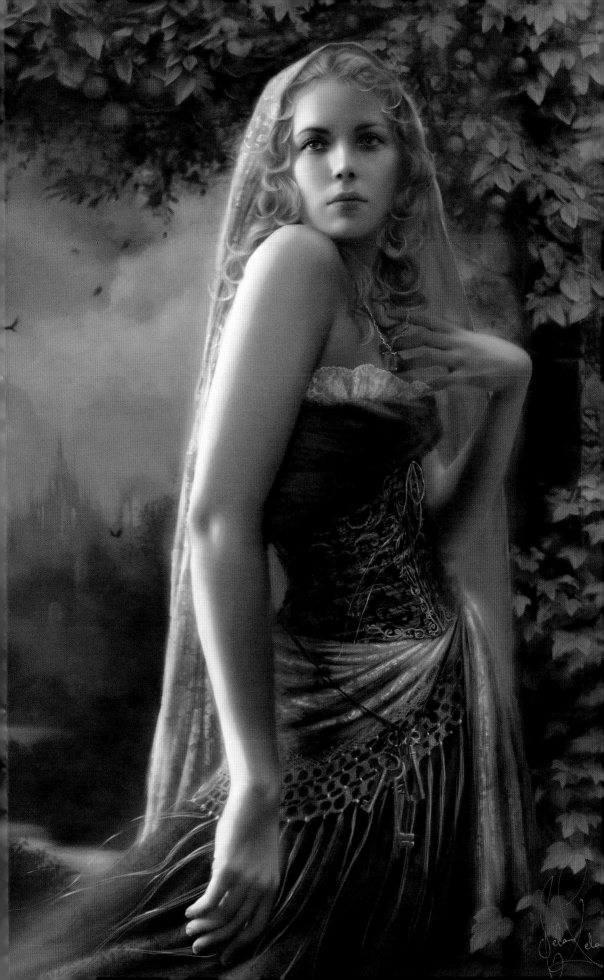

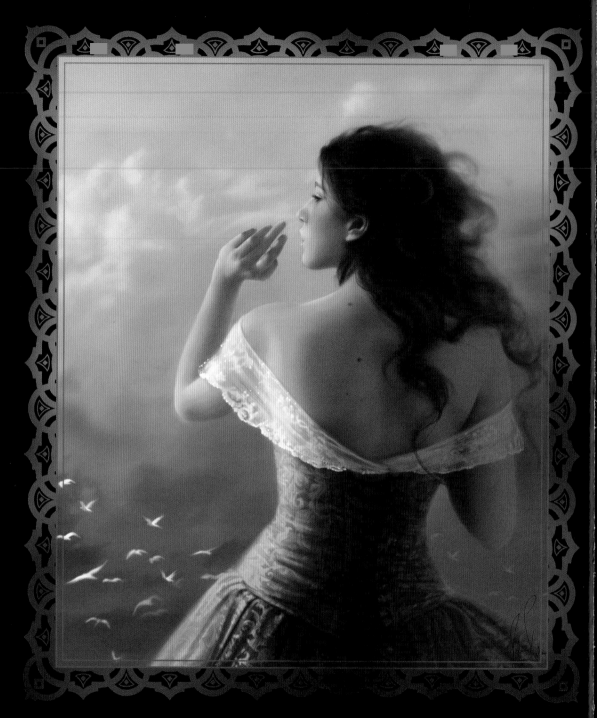

Believe 05/2007 ⚓

Cecilia believes in her dream. One day she will fly like the birds, following the clouds and the wind. She's the daughter of a brilliant scientist. Her father gave her the taste for creating machines and sometimes nonsense inventions. Birds always fascinated her, and she gives all her energy and strength to see her flying project completed.

Elixir 12/2006 ⇁

In the ancient world, a woman ruled the city of "Estirh". Her name was Queen "Nihaalen" and she was immortal. The Gods gave her the elixir of eternal life, in return she had to bring peace and justice to her people... but this gift became more of a curse for her, she was condemned to live alone forever.

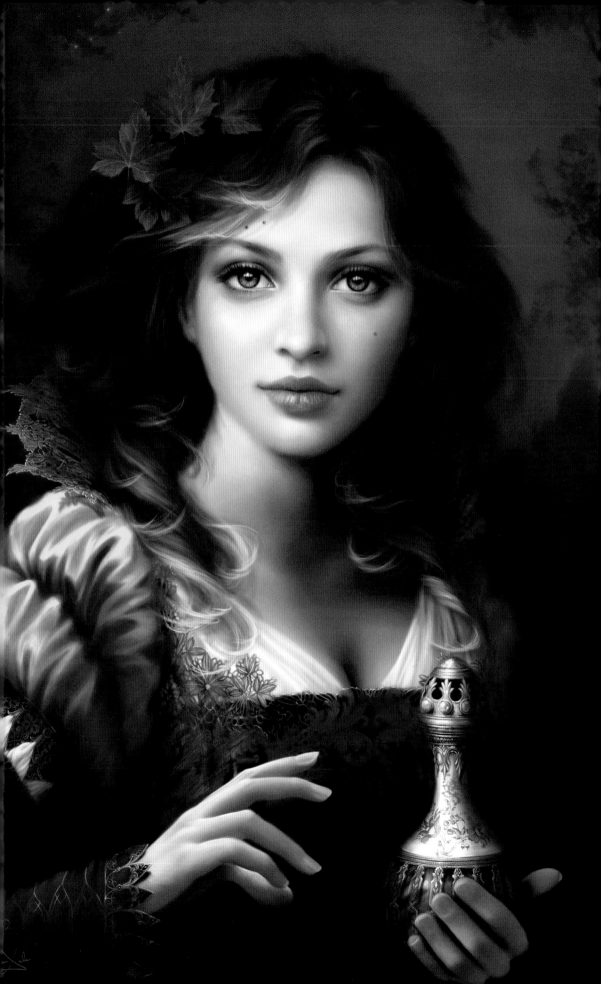

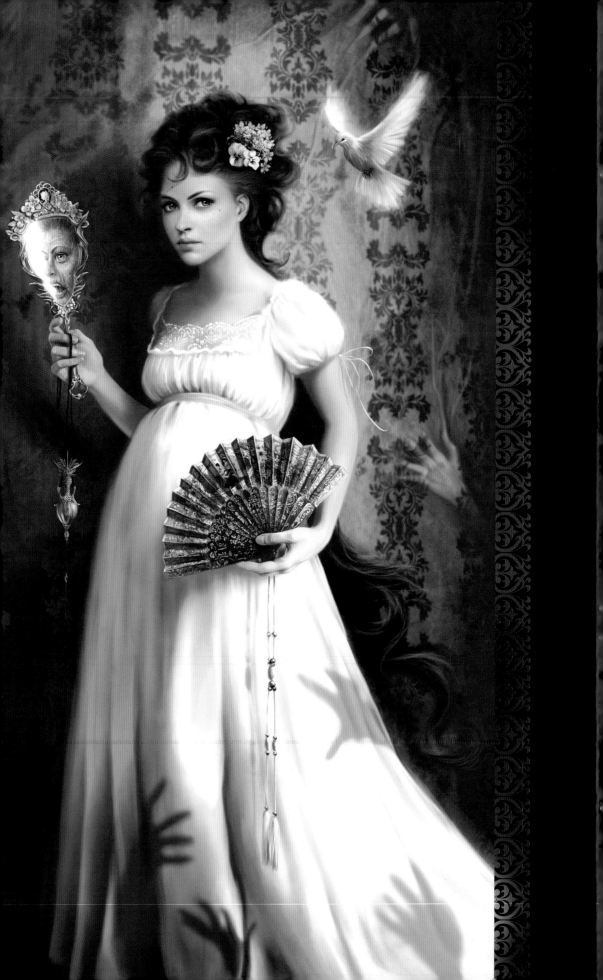

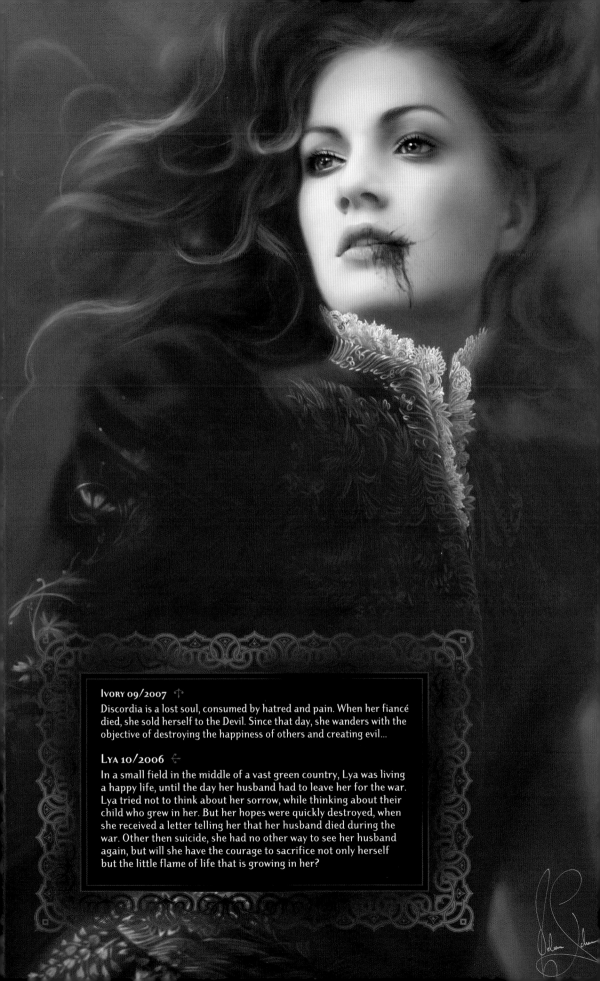

Ivory 09/2007 ✝

Discordia is a lost soul, consumed by hatred and pain. When her fiancé died, she sold herself to the Devil. Since that day, she wanders with the objective of destroying the happiness of others and creating evil...

Lya 10/2006 ←

In a small field in the middle of a vast green country, Lya was living a happy life, until the day her husband had to leave her for the war. Lya tried not to think about her sorrow, while thinking about their child who grew in her. But her hopes were quickly destroyed, when she received a letter telling her that her husband died during the war. Other then suicide, she had no other way to see her husband again, but will she have the courage to sacrifice not only herself but the little flame of life that is growing in her?

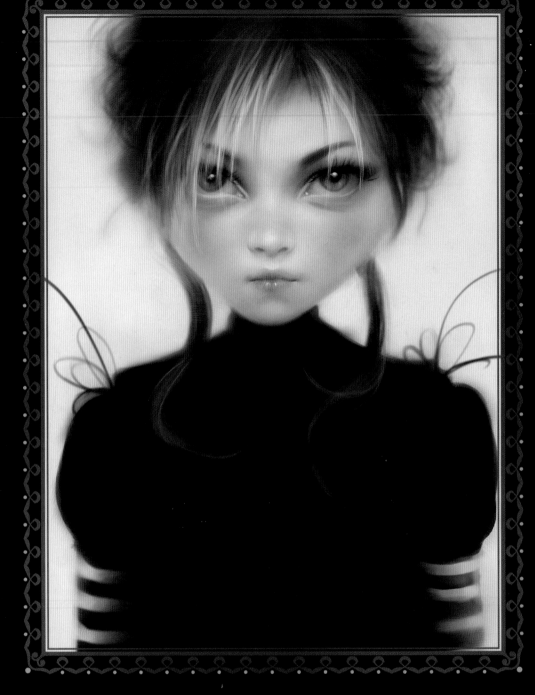

BIOGRAPHY

I was born in 1980, in a city near Paris. I've always been fond of drawing and painting. I discovered digital painting and got my Wacom about two years ago. Since that day I've been addicted to it.

I paint mainly fantasy subjects mixed with a classical touch. Since I've studied the history of art, I'm probably most influenced by all the Old masters. Painting is a real passion of mine. I can be in front of my computer creating worlds and characters for hours.

I've worked as a freelance illustrator for magazines such as Imagine FX, or SFX Company and other publishing houses. But I try to spend most of my time on my personal paintings.

I've been featured in many Illustration books like Exposé 4 (Master painted portrait), Exotique 2 &3, Exposé 5 (Excellence painted portrait), and Spectrum 14.

I'm currently living in Paris, working on a lot of new paintings and several projects. This artbook is my first one.